CREATIVE IDEAS IN PHOTOGRAPHY

DIANA K. MILLER

Copyright © 2013 DIANA K. MILLER

All rights reserved.

ISBN:1491072202
ISBN-13: 9781491072202

DEDICATION

Many thanks to Anna M. Streety, Brian & Cassandra Cornwell, Brad & Tera Nicole Baccus, El Torito & Casey Ayala & Eric Taylor with Taylored For You Photography

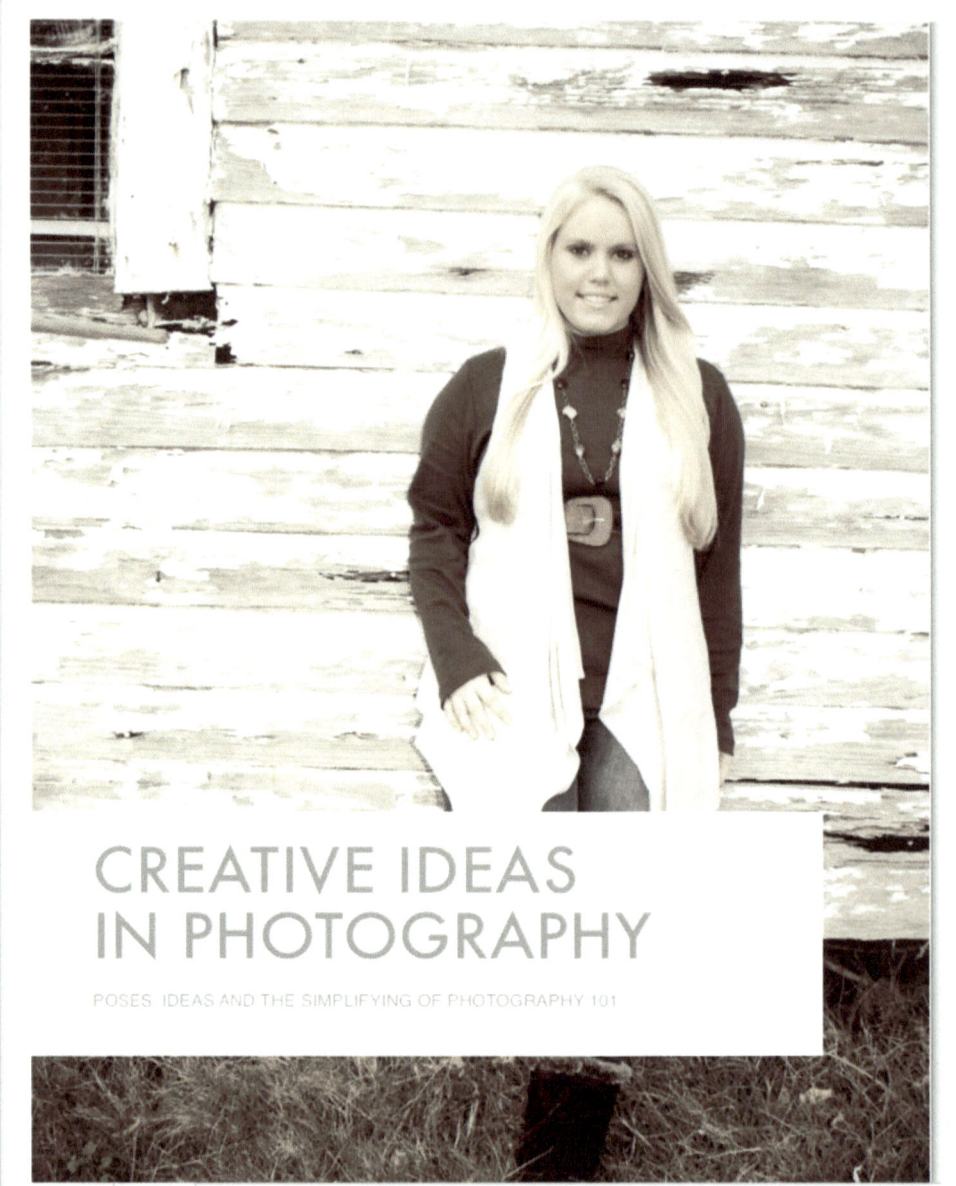

CREATIVE IDEAS
IN PHOTOGRAPHY

POSES, IDEAS AND THE SIMPLIFYING OF PHOTOGRAPHY 101

POINT OF VIEW

1.1 CLIENT COLLABORATION
1.2 EXAMPLE POSES

1 POINT OF VIEW

The objective of this book is to show you how to go beyond family portraits and how to start to excel in other areas of photography that are similar to family portraits.

The idea that photography is grabbing a camera and clicking away with very little effort doesn't seem true in the beginning, especially when you're learning how to work with a camera that has a ton of functions that you just aren't used to. This book is going to help you implement your ideas on a single subject.

The first thing that you need to understand is this: do not go searching on the internet for your poses. A great photograph has to do with many factors. A pose is only part of many equations that go into a great photograph.

A few ideas to think about when creating a great photograph for instance is lighting. Lighting can make or break a photograph. It's extremely important that you experiment with a friend or family member before attempting to call yourself a professional. Remember, a client hires you for more than the camera. The best way to experiment with lighting if you don't yet have access to a beginners lighting kit is to get flashlights and/or any indoor lighting will be great to experiment with. You may be able to take great photographs outside, but what about inside? Have you thought about what you would do at an event with low lighting and how your camera would react? How would you adjust the settings? You should be familiar with these ideas before attempting any event - especially weddings where low light is common. Software can fix a lot of problems with lighting, but your client isn't going to want to wait a months for you to figure out how to fix it. You need to be proficient with professional grade photographers software. Do not cut corners. You get what you pay for, so please do not expect it to come cheap.

Getting back on the topic of poses. Always remember that you should be very comfortable with your equipment before taking on a professional photographers title. If you say professional your client is not going to accept excuses as to why his or her photographs are blurry, grainy, dark, bright, over saturated and some are even picky when it comes to things beyond your control. For instance, his or her photograph doesn't look right because his or her teeth are yellow. Not your fault right? Wrong. Professional means professional. You've got to fix the obvious flaws within a photograph.

Poses can get you pretty far - with the right client, attire,

makeup and location. Some clients don't mind being picked up or thrown in the air, however others aren't as outlandish. Try to get to know your client before hand. Pass a few ideas and see what poses they like. Never assume the client wouldn't like your choice of poses.

You'd be surprised at the clients that want a photographer who is up for anything.

I've included a lot of photographs in this book with the permission of my clients. Which brings me to another important aspect of photography. If you choose to upload, share, print, scan, fax or make public any photograph you must have permission by the client in order to do so. Your insurance company would not be very happy with you otherwise. Just a little FYI (for your information.)

Every photograph you take will really be more about who you are. Your clients will see who you are within the photographs you take for them. Show off who you are, but deliver what they want. There is a common balance and any good photographer can find that balance easily. Don't be shy, be outgoing. Be what you would want your photographer to be. Take charge. The outcome of your photographs is from your point of view.

2 COLLABORATING WITH YOUR CLIENTS

I hit on collaborating in the last page and there are a lot of things that you really need to make sure you work on in the beginning. What questions will you be asking your clients when you sit down with them for the first time? Your answer is anything you would want a photographer to ask you. Put yourself in the position of the client. For instance there is a laundry list of questions you should ask a Bride and Groom who've come for a consultation. While at the consultation the photographer should always bring a contract. The contract protects both you and the client should anything go wrong. Always prepare a contract through reputable legal council. The protection the contract offers is a lot cheaper than hiring legal council when a problem arises after the fact.

After you've prepared the contract with reputable legal council and have begun the process of collaboration with your Bride and Groom you should be asking the obvious questions in the beginning. What are the clients names? Remember, it's important to get the full name of the bride and groom. If the bride has been married before make sure you are using her maiden name, not her previously married name. Some people continue to use their prior name for whatever reason they so choose.

What day and time will the couple be marrying? This one question can easily lead to many others, such as, "What time would you like me to arrive." Once again, this is important. You do not want to arrive at an event at the precise moment the event is to begin. When I shoot a wedding I am always there at least two to three hours ahead of time. There is no good excuse when you are late to an event. You have plenty of time if you prepare for the worst in advance. Another good question to ask in regards to time is the time in which the bride and groom are to arrive. How will the bride and groom arrive? How will they leave?

Never forget to ask about the rehearsal. If at all possible a good photographer will always attend the rehearsal for FREE. The rehearsal is the perfect opportunity for the photographer to become acquainted with the venue as well as the guests. The attendees are much easier to work with on the big day when they're familiar with who you are. You can also take the opportunity after the rehearsal to introduce yourself or lay out business cards for the next day. Always ask the bride and groom if you can place business cards out and

where you should place them.

Where is the location of the event? This is one of the biggest problems with photographers and the like. Once you have the name, address and phone number of the venue it is highly imperative that you print out a physical copy of the directions. Do not rely on a GPS that could fail at any given moment. Do not rely on a cell phone. Paper copies are always best and should be easy to keep up with in the clients file.

How is the payment going to be made? This may seem pretty simple, but tact is everything. You really should make sure that payment is made before the day of the wedding, unless another person at the event is going to be designated to handle the payment for them. Do not ever confront the bride or groom on the day of the wedding to discuss payment. If you have not made arrangements before hand you will have to wait until the couple arrives back from the honeymoon. You are bound to get thrown out of any venue by any family member at any given time by asking about payment during a wedding. Your contract should specify all payment criteria.

How many bridesmaids and groomsmen will there be? This is highly important. You will need to make sure that you account for every person in the bridal party. If you have an extra large wedding party you'll need more batteries and memory cards for the camera and flash.

What are the colors for the bridal party? You'll need this for means of preparation. It's important to know what to expect. Colors always bring about new ideas for creative poses!

Who is included in the bridal party? The bridal party goes way beyond bridesmaids and groomsmen. You could have best men, maid of honor, flower girls, ring bearers, minister, pets, parents and anything you didn't expect. You'd be surprised at who and what ends up in the bridal party. Have fun with it! Don't forget, no matter what your religious views are, you should always be respectful of others beliefs. Introduce yourself to the person(s) marrying the couple.

The best photographs you can produce for a wedding are not going to be full of colorful filters. Make sure that the content you provide is sufficient and acceptable for the client. If not, you could be handing over all of your original content free of charge or spend a few days in a court room. I always keep a backup of all photographs taken. Every year I buy a new external hard drive. So for 2009, 2010, 2011 and 2012 I have separate external hard drives. This is to ensure that you don't lose all of your client photographs simply because one hard drive failed. Do not use your computers hard drive for backup. You will be putting yourself in a compromised position. There are also a lot of times that clients lose their content and will need

additional copies. Like it has been said before, prepare for the worst.

Events are a lot of work, but once you're comfortable they are so much fun! You will really begin to enjoy the benefits of being a photographer, wait. . . no. an experienced professional photographer.

All events are different, I use wedding photography as an example of collaboration simply because it is more complex. There are many more questions to be asked in regards to events and such, however lets focus more on portraits.

Collaboration in relation to portrait photography is not as in depth as wedding photography, but nonetheless it is equally important. Lots of photographers will hire make up artists and professional hair stylists. Your photography may not be geared toward fashion so what questions would you ask? Well, for starters what type of portraits are they looking for? Many clients I get are looking for self portraits for college admission, pageant or modeling applications and some even want to have photographs of themselves to give as gifts for their spouses.

What's the most important part of portrait photography? For me, portrait photography was always about the feeling and emotions behind it. I love facial expressions, but there is a lot more to us than that. For example, I enjoy photographing hands. A baby girl in the hands of her father. A mother holding the hand of her son. These are all emotional times. A mother brushing her daughters hair may not seem like the prime opportunity to take a picture, but think about it. These are the times we commonly overlook as typical, not special. However, when we stop at the end of the day we look back on these simple everyday times and realize how extraordinary these times truly are. We photographers aren't just there to capture what we never see, it is equally important to capture our everyday routines. The things we over look, now that's a good pose - a good photograph.

A photography session is not just a set amount of time for one client to be photographed. A session is a hour or two of photographing their interactions. Give the client something to look back on.

If you're unsure on how to really collaborate with your client, perhaps you're new or simply need a better way of communicating with your clients try a few easy steps. Create a questionnaire or make a document of things you want to ask or bring to the table. You should also have a portfolio ready to show the client if need be. The majority of clients will want to see your prior work before agreeing to any contract with you for their event.

On the next page there is a little checklist of things you should always ask, no matter what the client. This is a basic checklist and you should come up with a form to call just your own. You should always be sure to print your checklist and save it in the personal file for the client. Be sure to make copies for both you and the client.

Name: JANE DOE

Address: 123 JANE DOE BLVD SOUTHWEST, JANEDOE, NEW MEXICO 00000

Contact Phone Number(s) (555)555-5555

Email Address: JaneDoe@exampleemail.com

Project Type: Portrait Photography Session

Details: Head Shots, Full Body Shots, Make Up Artist and Hair Stylist Requested

Contract Project: Yes

Signed Contract on File: Yes

Date of Project: January 12th, 2012

Time of Project: 12:00pm

Clients Included in Project: 1 (Jane Doe)

Project Payment: Received on January 10th, 2012

Invoice Number: #0101010101

Estimated Project Delivery: February 1st, 2012

Project Approved by: Photographers Name Here

Client Signature_____
Date:_____

Photographers Signature_____
Date:_____

Example:

Client has a birthday coming up and would like to have pictures taken for her husband. She is requesting the pink chair and black backdrop and example prop numbered 126 (black and pink hat)

A decent photographer will include as much detail as possible in the consultation. It's highly important that any changes made after the signing of a contract or application/checklist will mean that a new contract be drawn up. Make sure that all decisions are finalized the first time or the project could be pushed back to a time in which you or the client is not available. Some types of problems cannot be foreseen. Nonetheless, tread carefully and do the best you can. Document everything.

I've included a few traditional poses for you to use as as example. Feel free to come up with your own version of the poses I've provided.

Wedding Poses

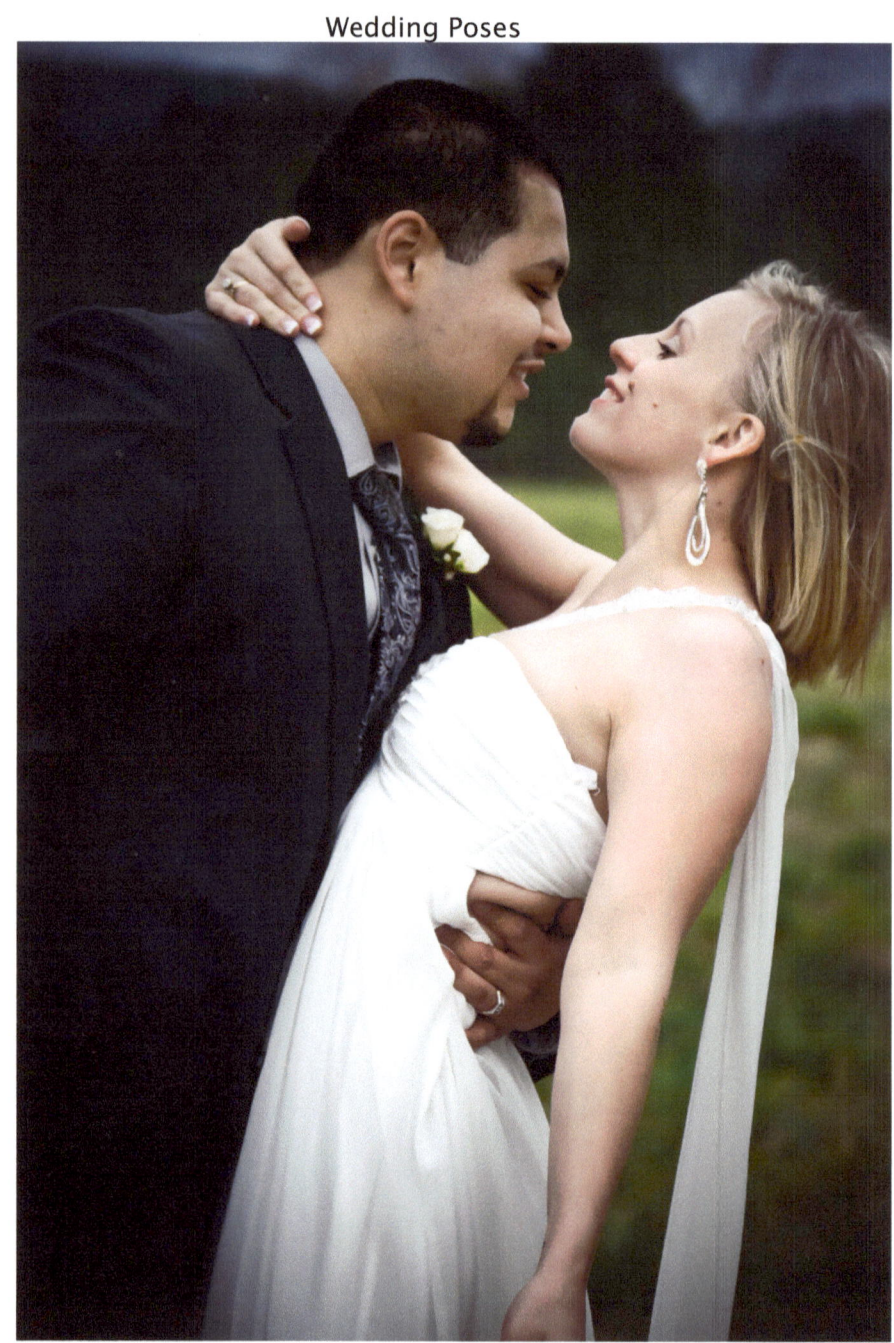

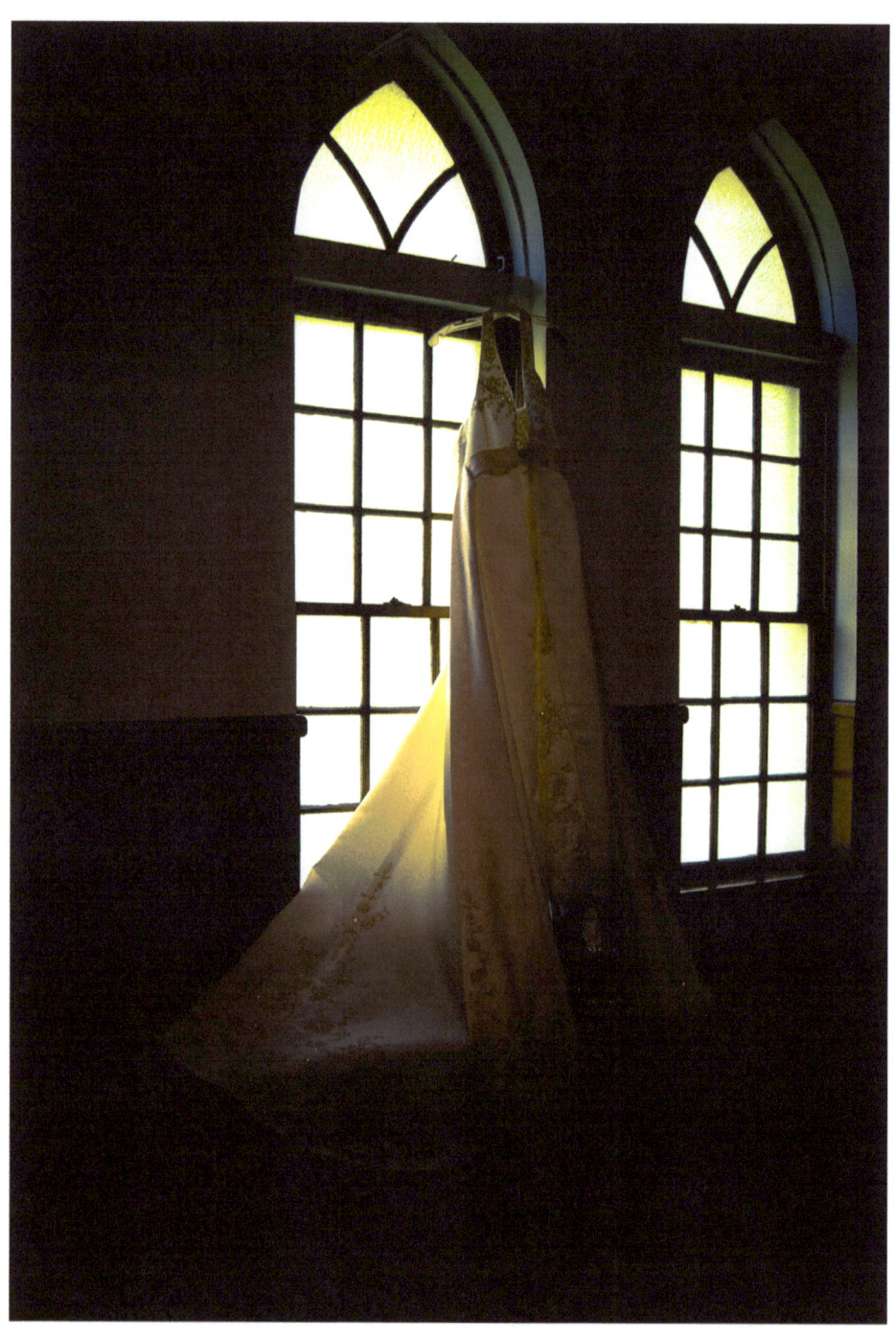

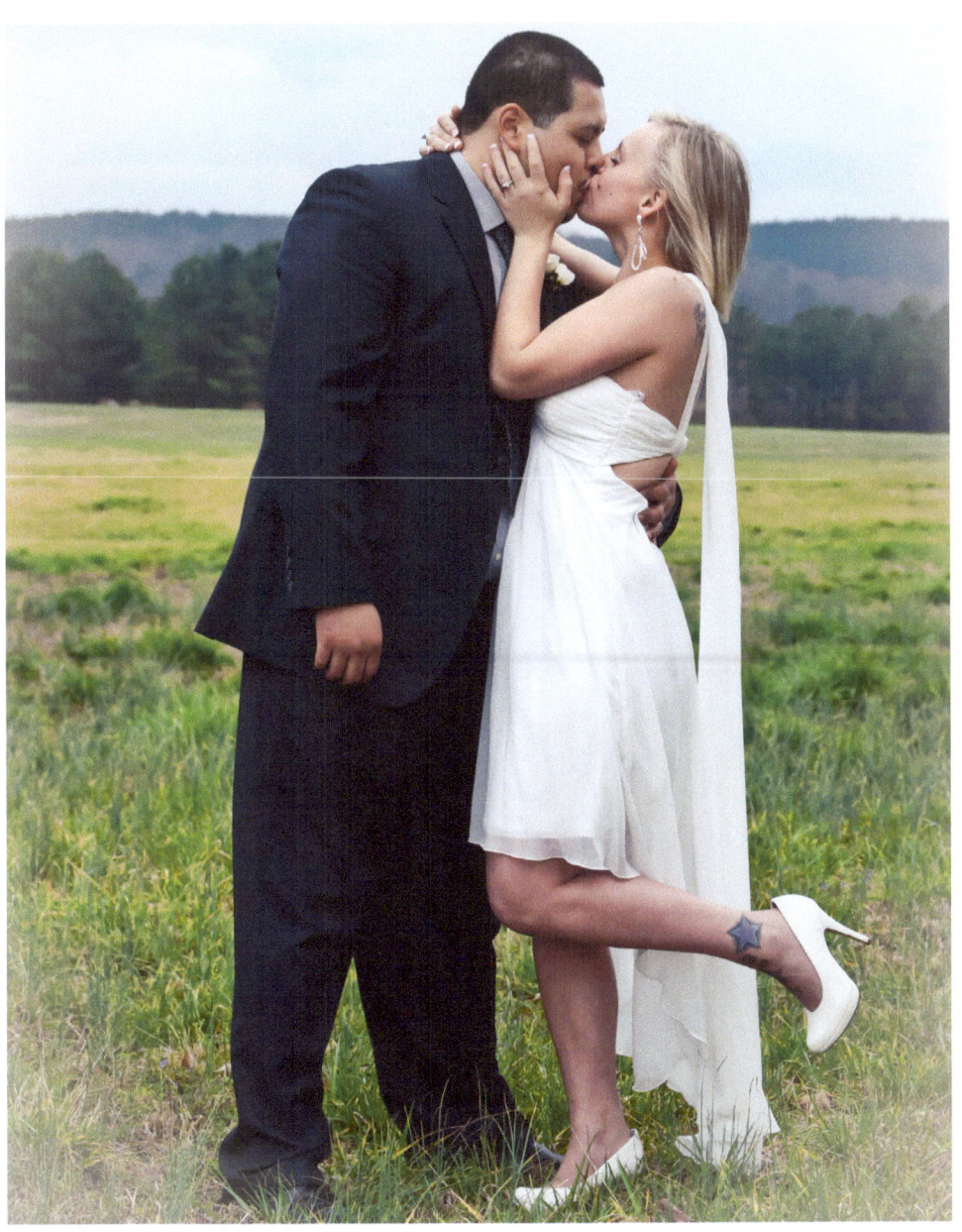

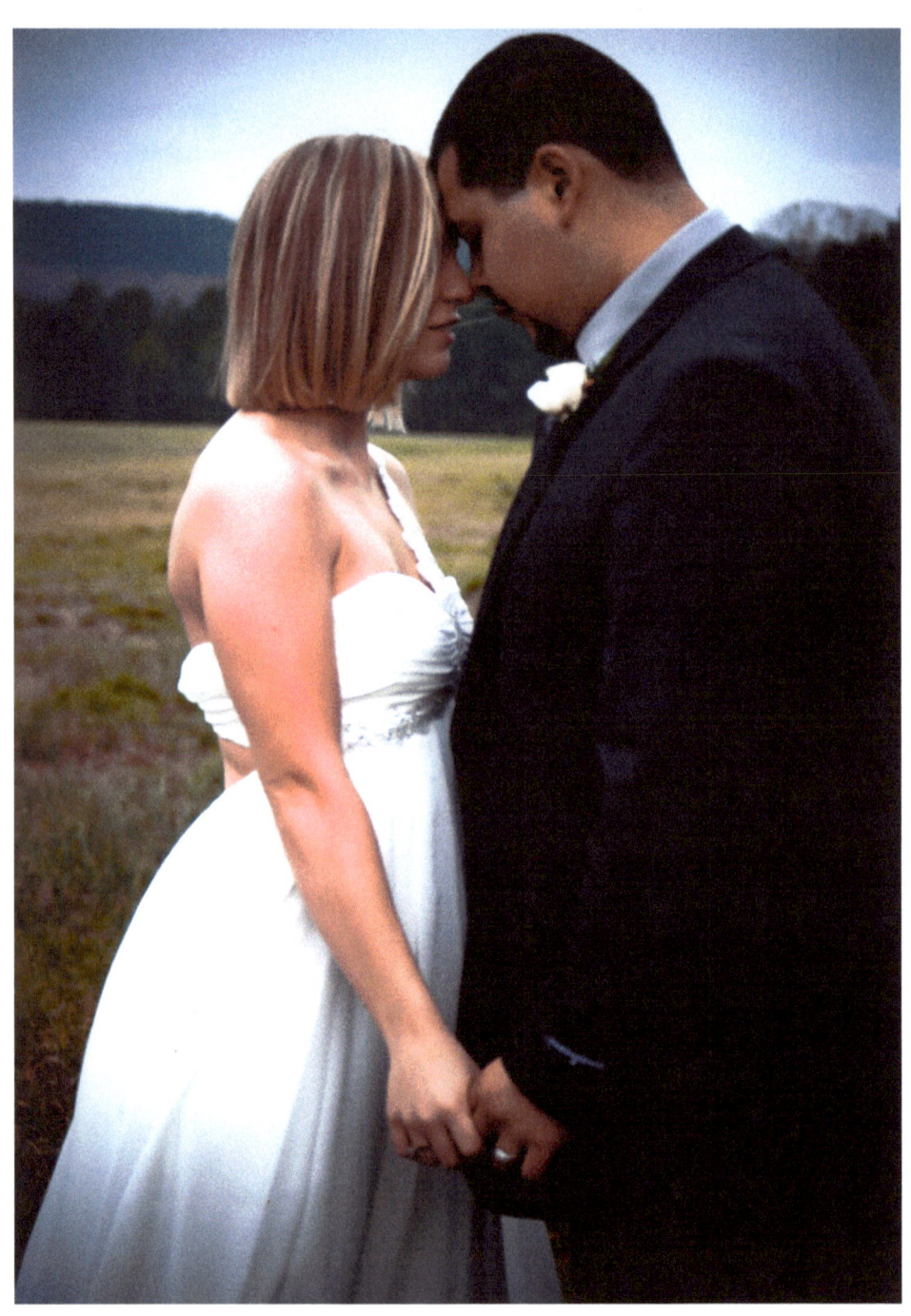

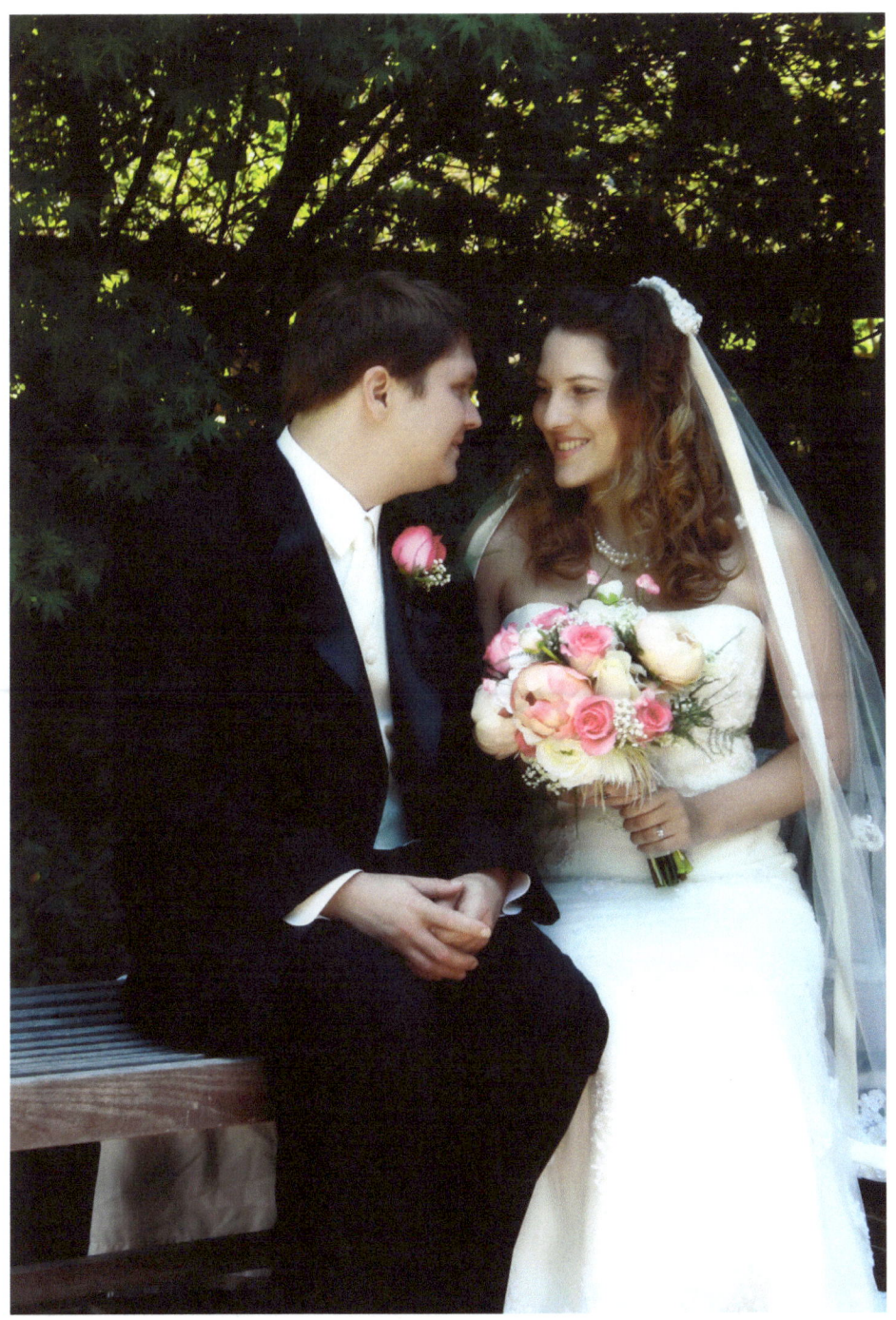

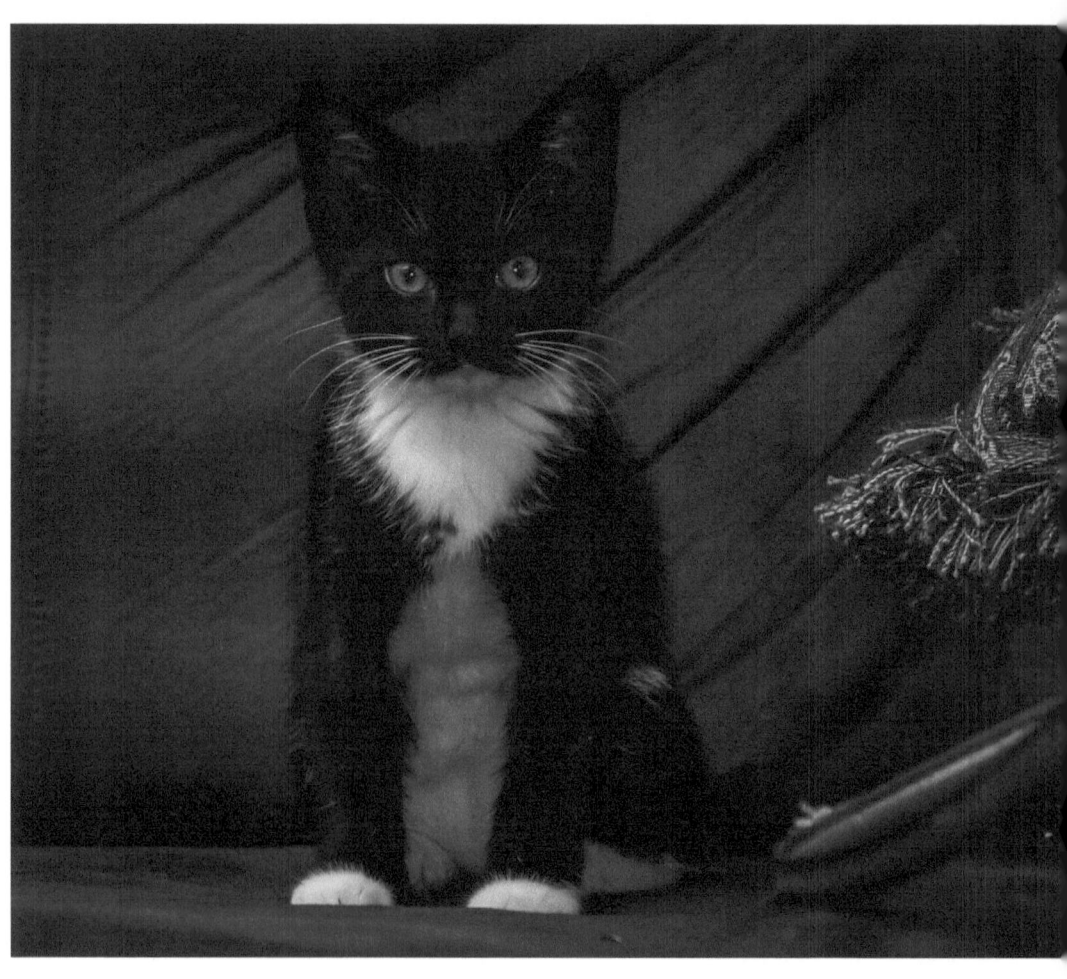

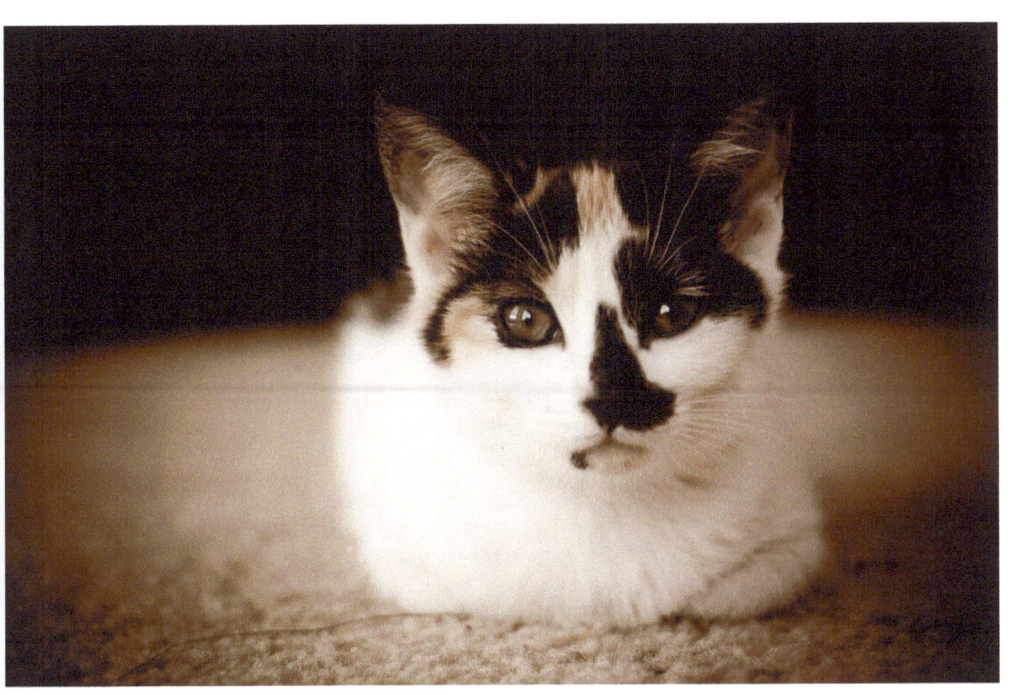

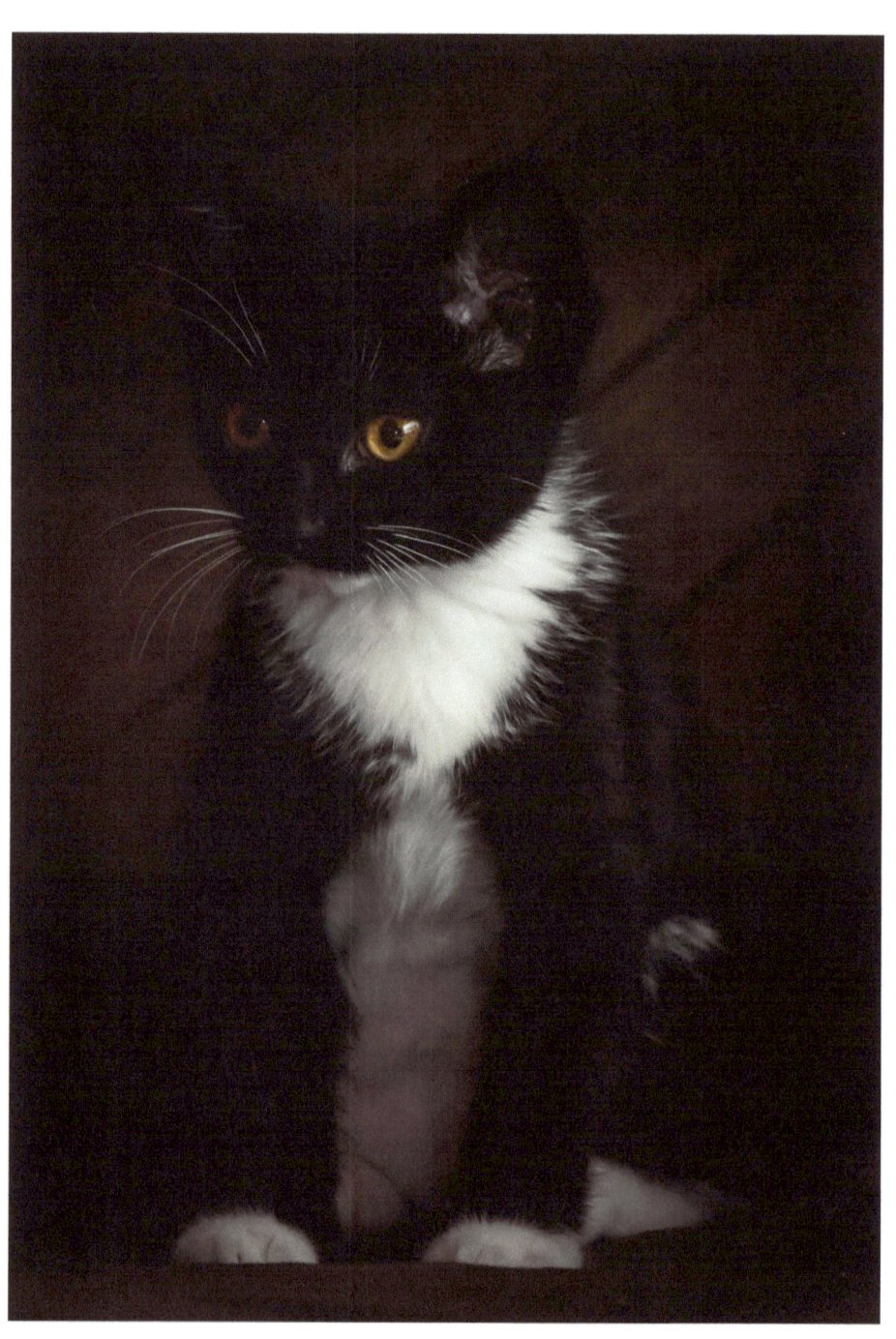

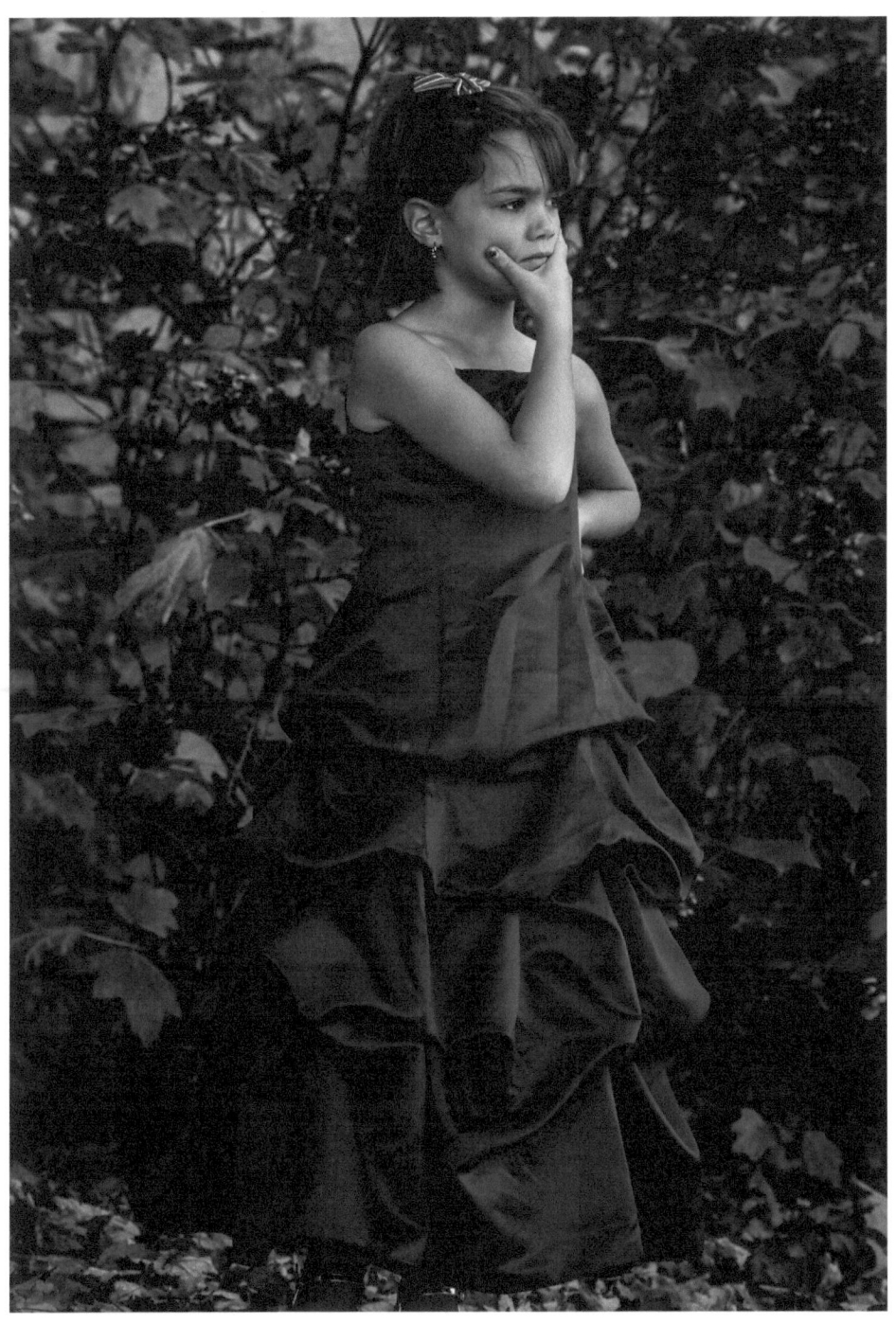

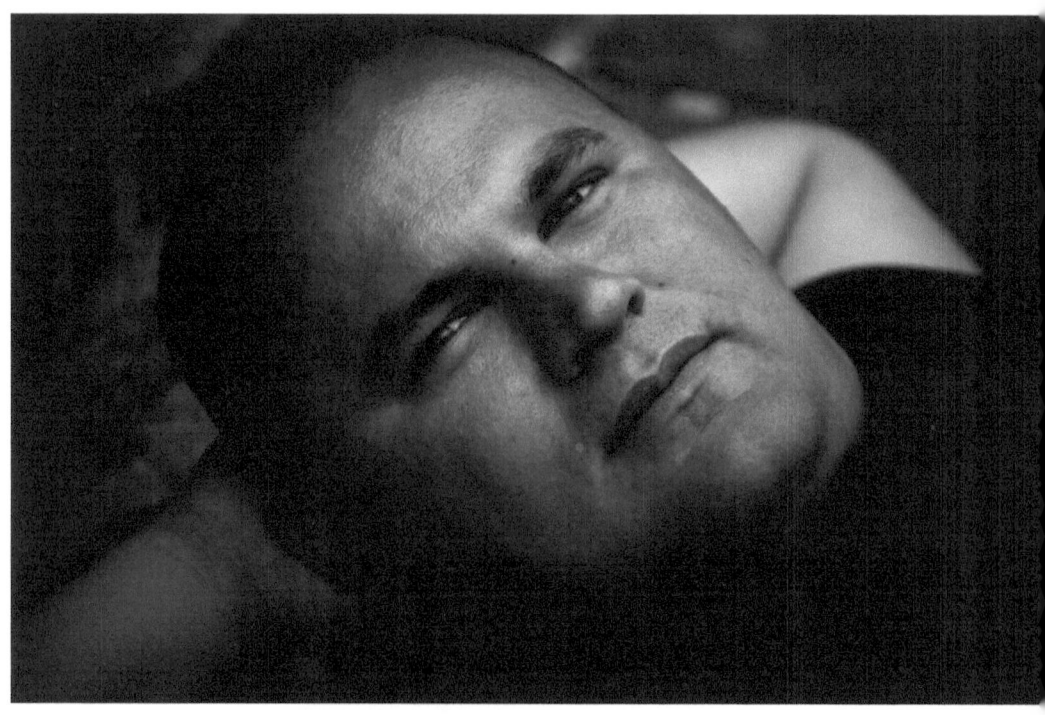

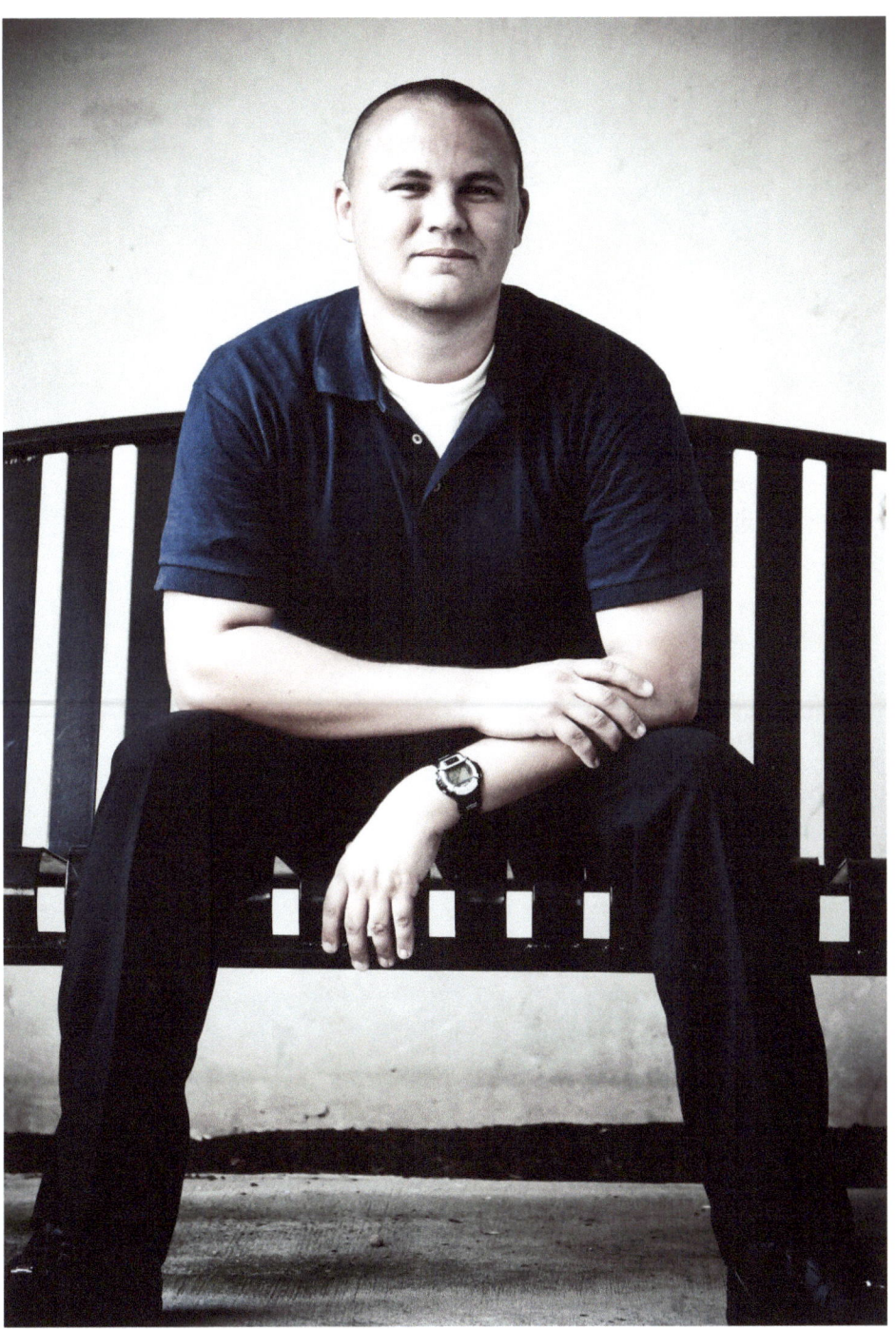

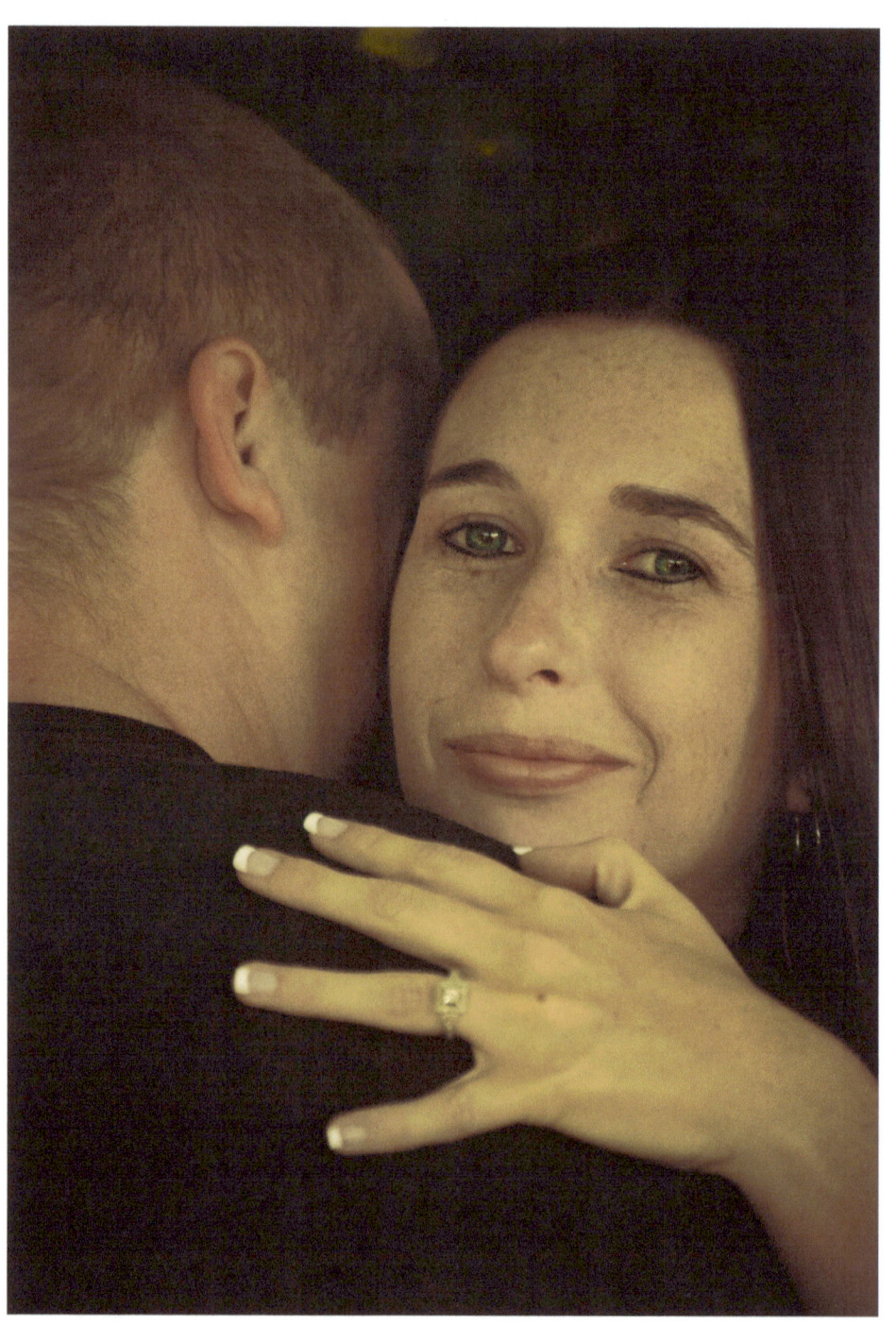

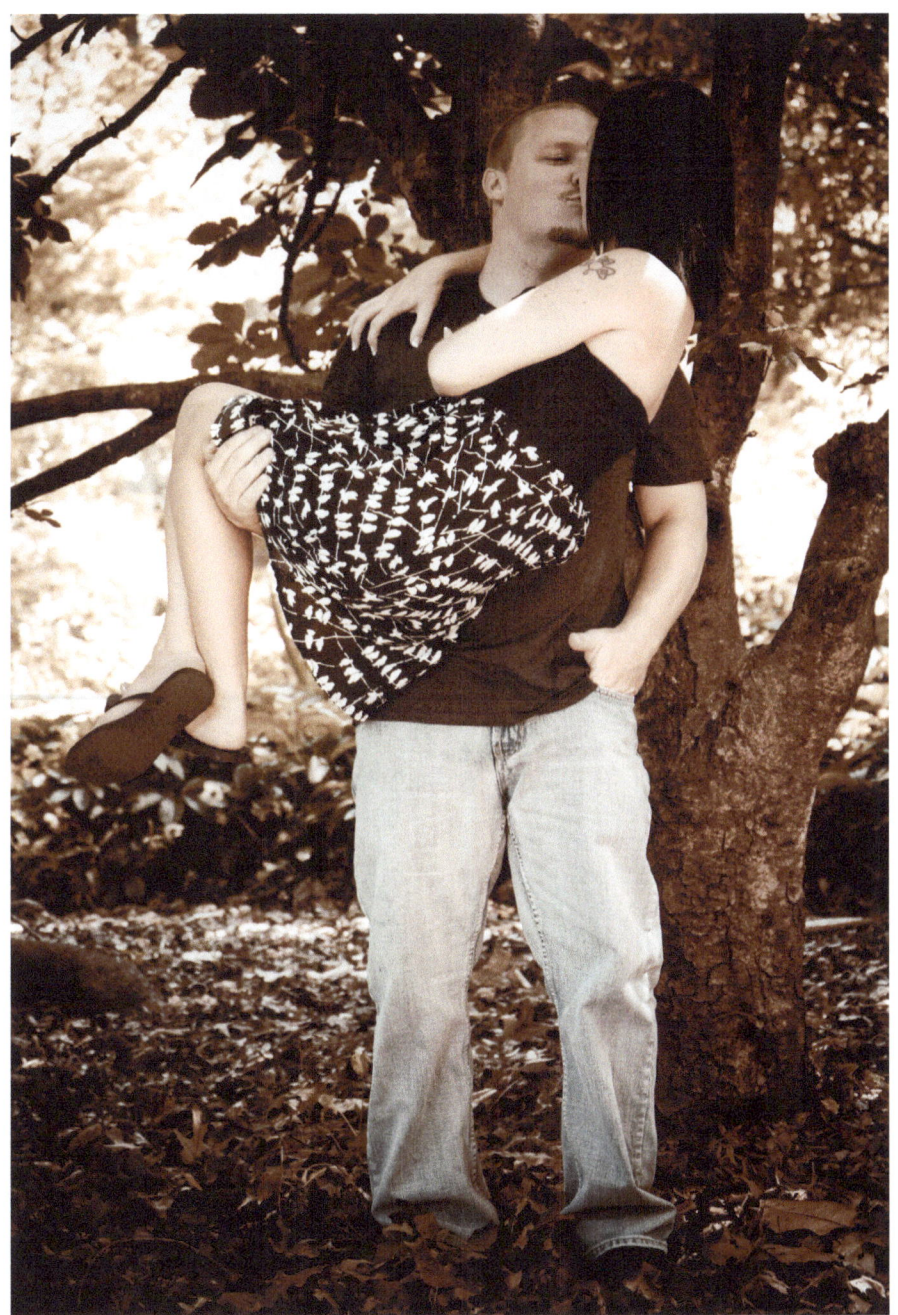

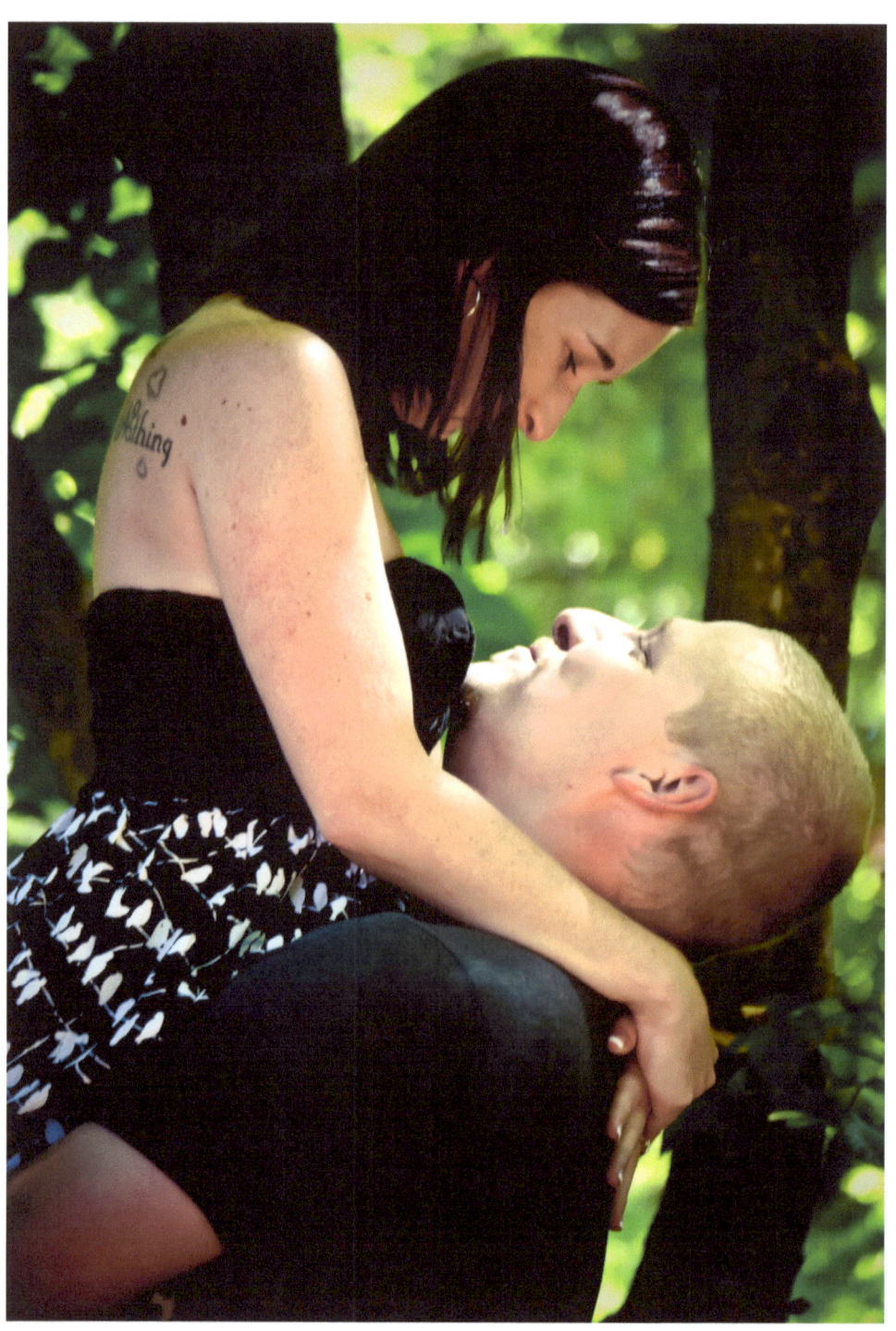

4
POSES: WHEN TO POSE AND WHEN NOT TO

Introduction

There are times when it becomes difficult to decide on when to pose and when not to, especially when photographing families. From personal experience I have found it profoundly easier to not pose children. However, you may find a large number of other photographers who disagree. However, how do you really know when you should pose and when you shouldn't?

WHY TO NOT POSE A SUBJECT

Before I get into why you should pose, I really want to explain the reasons why you would not pose a subject. Posing a subject is a great way to take away the natural look a subject has. I'm not saying you should never pose, I'm saying there is a reason for everything in photography. Here are a few reasons you would not want to pose your subject:

Some children have extreme difficulty sitting still and within five minutes of being told to be still he or she will become extremely cranky. The child's face turns beat red, tears fall and no one is happy at that point. You need to gauge your subject and see where he or she fits in. Some children may not mind, but there may be a lot of times where children simply want to be children.

Many adults will have extreme physical limitations that does not allow them to be posed in certain ways or even at all. The job of the photographer is the adjust to these situations and learn to adapt to these situations. This is one of the reasons why a good photographer will collaborate before the session.

One of the main reasons a client hires a professional photographer is to get away from the big box store photography studio. They want variety and creativity. Clients do not appear to have a very good time during the session if they aren't allowed to express themselves.

A photographer is more likely to get more unique photographs of the subjects by allowing more freedom during the sessions. The more photographs that are taken the more options the client has at the time of proofing and development. If the client doesn't have a lot of poses to choose from, the photographer will not make as much as he or she possibly could have. While we love what we do, we also have to make a living.

Have you ever tried posing a cat or a dog? If you have, you have probably had a difficult time getting them to sit still for any longer than two seconds (unless you're one of the more fortunate owners of a trained pet.) At some point in your career you will have to stray away from the posing and figure out a creative way to get the shot. If you have pets, use them as your test subjects.

Weddings, weddings, weddings. There is no way in the world that you are going to be able to stop a ceremony to get the perfect shot. You must be able to concentrate, focus and take your best shot. Test on moving objects to perfect your skill.

Posing isn't going to help you with your skill level. You should always be working towards one goal or another. No matter how big or small that goal is, go for it.

Natural shots are just as important as posed shots. It's always

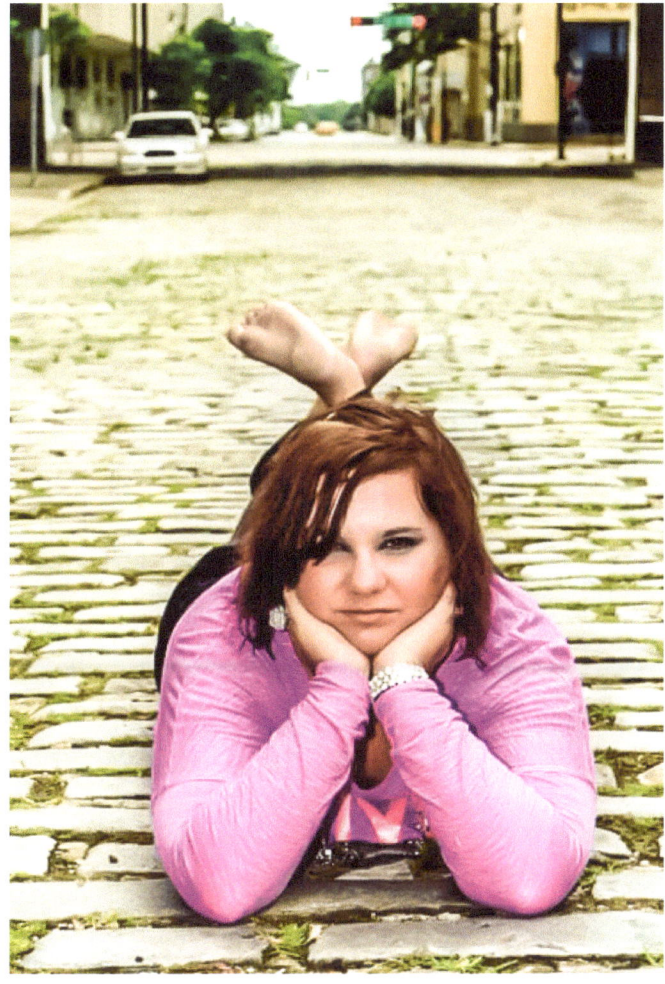

important to show a 50/50 interest in both. Kids aren't just smiling and crying. Children all have a wide variety of "looks."

Once in a lifetime shoots are sometimes the shots you never expected. Always be prepared to take a shot at any given moment. You never know when one is going to pop up.

Most importantly have fun not posing. You really learn to pick up your own style. You may ever have a better or more efficient way of photographing - for you.

WHEN POSING THE SUBJECT IS THE BEST OPTION

Posing your subjects may not always seem like the best option at times, but it can really become beneficial to your learning. In the beginning you'll notice with adult subjects and maybe at times with children that you have just got to get a certain pose. Maybe the look on the subjects face or the attire has you drawn to a certain pose, no problem. Just be sure to not pressure and rush the subjects. Be patient and be on your toes. Adult subjects are obviously easier to pose, but children can be a little more complex.

Here are a few good reasons to pose your subjects:

Events, wedding specifically are times you may find a huge need to pose your subjects. At the right time, perhaps at the reception you may want to get certain shots of the couple, bridesmaids, groomsmen and other family members. However, remember that it's never okay to pose when the bride and groom are preoccupied with guests. A good photographer should have somewhat of a timeline to go by. The bride and groom should be aware of the time lime so they can be aware the day of the event.

Newborns are very easy to pose to get the perfect shot. You should be collaborating with the parents on the poses before hand. Do not take unnecessary risks and make sure as the photographer that you have a first aid kit and cell phone for emergency purposes should anything go wrong.

Family portraits are not always required to have a pose, but you will find that a parent would like a certain shot that will go perfect with a certain color in their home. Listen to your subjects, let them guide you and run with it.

High school and college photography the majority of the time are going to require poses. College applications can require certain photographs of the subjects for sorority/fraternity applications. These types of pictures are highly important and require great detail. Do not cut corners with these types of photographs and be sure to pose according to what is required in the application the subject has. This is considered a high risk photography shoot and personally I would make sure a contract is drafted for insurance purposes. You do not want to be in the middle of a lawsuit because there are not any photographs of the subject in a certain pose.

Commercial photography is a highly posable opportunity. Remember that any commercial photography should be contract required. Do not take chances, even if the person(s) or business(es) are friends of yours. You can not assume that there will not be

problems of any kind. Lawsuits can be very complex and expensive.

Modeling sessions are always fun with hair stylists and makeup artist. As a photographer you can really use your creative skills with these types of photography. Boudoir photography is a great type of modeling session also. You really should get your creative juices flowing!

Speaking on boudoir photography always remember that boudoir photography is NOT pornography. Boudoir photography is classy, clean and usually for an occasion like Valentine's Day, anniversaries, birthday's or even Christmas! Sit down and think of different poses and collaborate with the subject first. They must be comfortable with the poses or the subject may feel uncomfortable and therefore appear uncomfortable in the photographs.

The best advice I can give to any new photographer is to never take unnecessary risks, be patient. Every session will fall into place and before you know it, you will become the professional photographer you want to be.

ABOUT THE AUTHOR

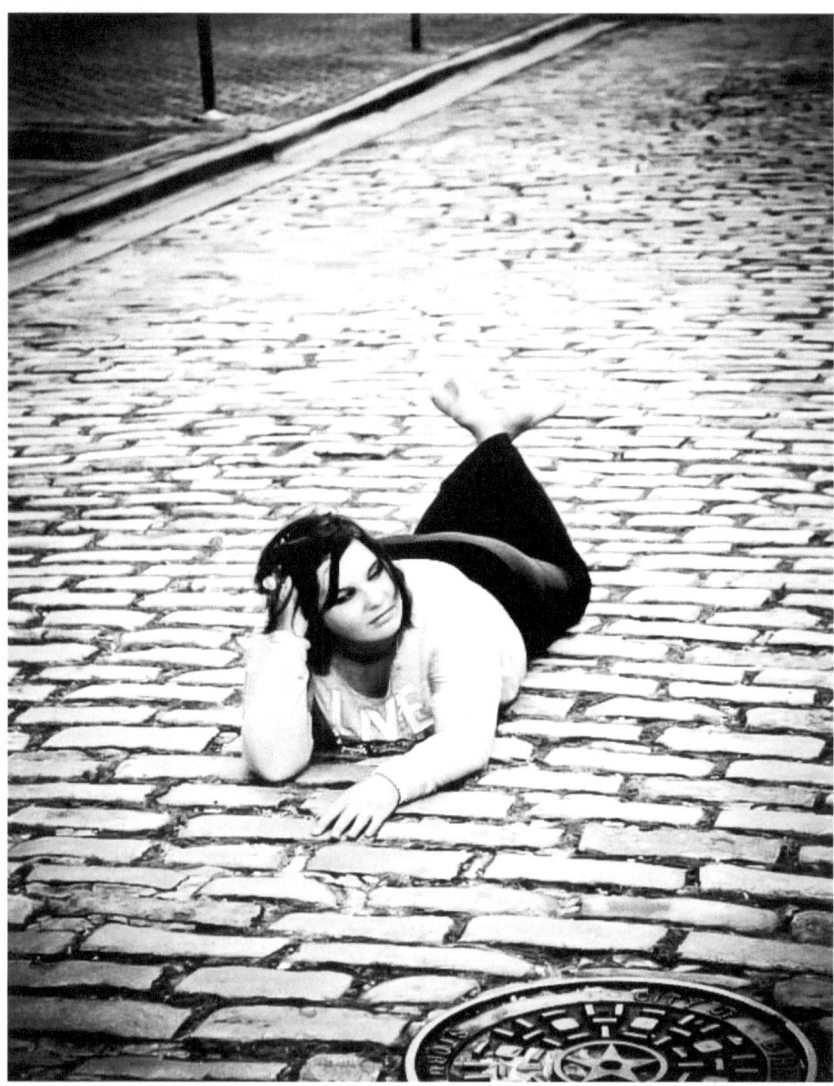

Author of, "Confessions of a Teenage Bride" and photographer at Diana K. Miller Photography brings advice on the topics of photographic poses and advice on fundamental standards in amateur photography 101.